Ruth Artmonsky & Brian Webb

F H K Henrion

DESIGN

Antique Collectors' Club

Design Series format by Brian Webb
Design: F H K Henrion © 2011 Ruth Artmonsky and Brian Webb

ISBN 978-1-85149-632-7

British Library Cataloguing-in-Publication Data
A catalogue record for this book is available from the British Library.

Antique Collectors' Club
www.antiquecollectorsclub.com

Sandy Lane, Old Martlesham,
Woodbridge, Suffolk IP12 4SD, UK
Tel: 01394 389950 Fax: 01394 389999
Email: info@antique-acc.com
or
ACC Distribution,
6 West 18th Street, Suite 4B,
New York, NY 10011, USA
Tel: 212 645 1111 Fax: 212 989 3205
Email: sales@antiquecc.com

Acknowledgements
With thanks to Marion Wesel-Henrion and the Design Archives,
Faculty of Arts & Architecture, Brighton University.

Page 36 (right) Courtesy of the Trustees of the Imperial War Museum:
IWM PST 004000, all other images courtesy of the F H K Henrion
Archive, University of Brighton.

The cover is reproduced from a proposed illuminated sign for Courage
Brewers, 1968 and the endpapers from a Letraset transfer sheet, 1950s.

Published by Antique Collectors' Club, Woodbridge, England
Designed by Webb & Webb Design Limited, London
Printed and bound in China.

'The vocation of a designer is essentially at root the same as that of the artist. But unlike the artist who has largely cut himself off from Society, the designer has to function within the limitations imposed by Society. Whereas the artist works to self-imposed limitations, the designer accepts those imposed from outside, by the commissioning body, and the specific problem he is called upon to solve. But this difference is only one of degree... The good designer has to please himself as well as his client'.

F H K Henrion, *Society of Industrial Artists and Designers, 1962 Presidential address*

+TATE +LYLE

2 lb
granulated
sugar

Design
F H K Henrion

A packet of granulated sugar can be found in most kitchen cupboards; it is white with simple blue bold lettering announcing that the contents have been processed by Tate & Lyle. Most consumers would barely give the packet a second thought. They certainly would not appreciate that this iconic design has served its purpose for over fifty years, an extraordinarily long life in this age of continuous repackaging and re-imaging. Its designer, F H K 'Henri' Henrion, ranks within the highest echelon of British graphic designers in the post-war period. He was perhaps the most international of designers with a network of professional contacts across the globe.

His remarkable professional career, with its peaks of enthusiasms and influence, closely mirrored his own physical maturing. In his youth and early manhood his work was full of fun and experiment, a flexing of muscles, largely within the media of posters and press advertising but with sallies into exhibition design, peaking with his pavilions for the Festival of Britain. In the 'middle age' of his career Henrion had an even more challengingly responsible role, taking design up to board level significance with his evangelism for corporate identity, and, via his many governmental and professional roles, raising its status. In his later years as a doyen of world designers, through his writing and lecturing, he was not only able to encapsulate what had been achieved in the post-war decades of graphic design, but to share his experiences and philosophy and to point ways forward.

Henrion was born Heinrich Fritz Kohn in Nuremburg, Germany on 18 April 1914. His parents were German, but there were French links as some of his mother's family had established themselves in France. With the rise of National Socialism, his parents, concerned for his safety, sent him to live with his mother's relatives in Paris in 1933. It was there that he started his design apprenticeship, in a textile studio working up speculative designs for manufacturers. Although this is not how he had hoped to start his career, Henrion later considered the two years he spent there as of considerable benefit: 'I found having to do four designs a day a most fascinating and important

Textile design, 1933. One of Henrion's textile designs for the Paris firm of Fred Levi. The artist Sonia Delauney was also working in the Levi studio at this time.

discipline. This sort of working habit, not waiting for inspiration, or saying I don't feel like it, but having to do that quantity, was the most marvellous work preparation for my whole life'.[1]

From the start Henrion had been attracted to poster design and he eventually got a place in the Ecole Paul Colin, one of the most distinguished poster designers in Paris in the 1930s. Later he recalled the magic of the time: 'to be at his school was to take part in the life of Paris at the time … while we were all working furiously, ambitiously, and hopefully, somebody came in from the street and said "Have you seen the new poster by Cassandre?" and we would all rush into the street until we saw the new affiche, would stare at it for a long time, then go back and discuss it, compare it with others, analyse it, try to learn from it.'[2]

Largely assigned to filling in the lettering on Colin's posters – Colin having little interest in typography – Henrion yearned to do work with the more experimental Cassandre, a rival of Colin's. An offer to join Cassandre's studio was, however, frustrated by Cassandre leaving suddenly for Italy on the German invasion of the Rhineland. Nevertheless, one of Henrion's posters produced at the Ecole won a national poster competition and, in 1936, Colin supplied a needed reference describing Henrion as one of the best of his students, a quick and interested learner, and as having a great imagination and an eclectic talent. 'Eclectic' was perhaps an unusual adjective to apply to a young student, but it was perceptive as Henrion was to prove extremely eclectic, drawing his ideas widely from many disciplines, the social as well as the physical sciences.

Before coming to England Henrion spent a short time in Palestine where some of his Ecole posters were on show at a trade fair. Fortuitously these were seen by the British Crown Agents for the Colonies, who immediately asked him to work on an advertising campaign for citrus fruits; it was this that brought him to London in 1936, the place he was to make his home for the rest of his life.

Arriving in England Henrion was again to have a lucky break, for a friend of his youth, Walter Landor, was working at that time as

a designer with Milner Gray and Misha Black in their Industrial Design Partnership studio in Bedford Square. Henrion was quickly drawn in to work on exhibitions with the Partnership, and this being a totally unfamiliar area to him, he had to show some of the 'quickness to learn' ability that Colin had noted. When Milner Gray was appointed head of exhibition design at the Ministry of Information at the start of WWII Henrion was to follow him there. Meanwhile, just prior to the war, Henrion was beginning to build an independent practice, getting his first London Transport commission in 1936, and in 1939 his first poster commission from the Post Office.

When war broke out Henrion, although Jewish, was caught up in the anti-German hysteria and was interned in a camp at Press Heath, Cheshire. Such was the reputation he had so rapidly built up for himself in England that Helen Roeder, Joint Honorary Secretary of the Artists's Refugee Council, was able to write in his defence (20 September 1940) – 'His experience and talent as a propaganda artist could be of great service to this country, to which his loyalty is beyond question'; and so it proved to be. During the war Henrion worked for the Ministry of Information, the Army Bureau of Current Affairs, and the United States Office of War Information (USOWI) simultaneously, as well as doing some general commercial work for Crawford's Advertising Agency and several 'governments in exile'. He wrote of the pressure he was under: 'A fifteen-hour day was commonplace – we even thought nothing of working through the night. We didn't have the problem of peace-time attitudes. Everything was needed urgently. There wasn't time to consider niceties, like whether the square corner should be rounded. Everything went through quickly and enthusiastically.'[3]

Henrion had started his career with the ambition of becoming a poster artist and the war certainly gave him the opportunity to develop his ideas. Throughout his career he was to design some 160 posters, stretching from his student work 'Etat' for the French railways in 1934 to an Aids poster in 1990, the year of his death. But his most prolific period of poster design was during the war and into the fifties, a period that he referred to as 'the heroic age of the poster'. An archived report from the Central Office of

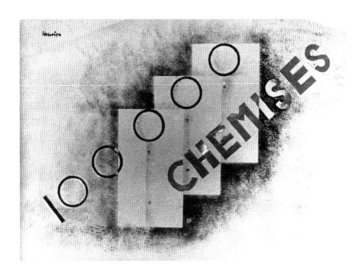

100,000 Chemises, c.1934. The last three zeros make the shirt collars; an Ecole Paul Colin student exercise showing the influence of the leading French poster designers Cassandre and Carlu as well as Colin.

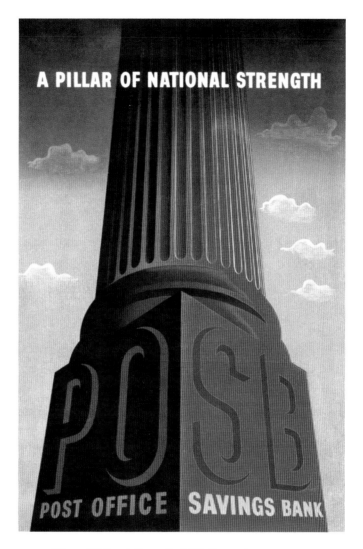

Pillar of National Strength, 1939. Poster design to reinforce the image of the Post Office Savings Bank in response to large-scale withdrawals of money at the outbreak of World War II. Later in the war the messages became more direct – as in *His Needs Come First: Lend Don't Spend* illustrated on pages 46-47.

Information (24 June 1946) in support of Henrion's application for naturalisation notes that: 'Mr. Henrion began his work for the Ministry of Information in 1941. Almost without a break through the remaining years of the war he was designing posters and exhibitions commissioned from him by the Ministry.'[4]

The Ministry of Information had been set up on a temporary basis, and was at first given little credence by the other government departments who considered it as something of a joke, a refuge for a ragbag of writers, artists, journalists and film and advertising men. It certainly took the Ministry some time to get down to business: after a quick turnover of some four successive ministers and five successive director generals, in 1941 it came into the steadying hands of Brendan Bracken. Under Bracken not only did the Ministry become highly productive, but it built up a remarkable reputation servicing many of the Civil Service departments which had initially derided it. Bracken established campaign divisions to canalise the requests of these 'client' ministries. In all some one hundred campaigns were run during the war. Henrion was largely involved with those for the Ministry of Agriculture and for the Post Office (in particular for the Post Office Savings Bank).

The Ministry of Agriculture campaigns were largely to encourage people to make the most of their wartime circumstances – to grow their own food, to keep animals for food, and to use their basic rations in as imaginative a way as possible. Some of Henrion's posters for these campaigns stood alone, others were for exhibitions on the same themes. It may possibly have been due to these posters and their associated exhibitions that his name linked associated with things 'rural', and that this influenced his being commissioned to design the Country and Agricultural Pavilions for the Festival of Britain in 1951.

Henrion's wartime work for the Post Office started in 1939 when he produced the iconic poster *A Pillar of Strength*. A note from a Post Office employee in September 1940 stated: 'I wrote to say that I saw a selection of the work by F H K Henrion some time ago and was impressed by it. He was accordingly commissioned to prepare designs for two folders and later recommended to the Savings Bank

Department by whom he was commissioned to prepare a poster on War Savings. There is no question in my mind that Mr. Henrion is a commercial artist of high merit.'[5]

The Post Office Savings Bank (POSB) was in competition with the commercial banks and needed to combat the impression of the general public that the money they handed over the counter in the local Post Office was kept in the counter drawer. In his *Pillar of Strength* poster Henrion used the image of Nelson's Column to attach to the POSB feelings of strength and security that had become associated with the sometimes near fortress-like architecture of the banks. The POSB wartime poster campaigns mirrored the phases of the war itself. With the early threat of invasion the posters were along the lines of 'lend to defend'. Later the campaigns turned to the offensive with the war moving to the Continent, with poster images of attacking Spitfires and Hurricanes. Then, towards the end of the war, the posters became more optimistic, hinting of the idyllic times possible after the war, particularly if your savings were with the POSB. So Henrion's posters shifted from *Action Stations* to *His Needs Come First* and *Make Your Money Work* to *Looking Ahead*. Eric Newton, the art critic of the *Sunday Times*, in 1943 bracketed Henrion with Abram Games as 'two of the most talented of the younger generation of poster designers in Great Britain today'.

Henrion recalled the pressure as D-Day approached of working with a team of fifteen designers making eight posters a fortnight: 'multi-lingual posters with pictograms'. No doubt Henrion's tri-lingual competence came in handy for this, and on other projects he did for 'governments in exile'. One of his most striking posters for the Dutch was *En Nu Vooruit* (And Now Forwards) in 1945, which shows a clenched fist breaking through the chains of captivity.

For the Americans, whose concern seems to have been to put across America's potential cultural contribution to the future of Europe, Henrion produced a striking poster *Young America* which Austin Cooper in his *Making a Poster* (1944) described as 'a design that appears to me as a perfect example of "fitness for purpose". Fly-posted in a crowded street as I saw it first, it sang out its message with unquestionable directness – in all respects a fine performance

by one of the young generation'. The most frequently quoted poster from Henrion's work for the USOWI is *Four Hands* intended to be shown on the Continent after liberation: a black swastika being pulled apart by four hands painted with the Stars and Stripes, the Union flag, the Tricolore and the hammer and sickle.

Very many of Henrion's wartime posters made use of photomontage, a technique that had been used in the twenties by such designers as Cassandre and McKnight Kauffer. But it was the German, John Heartfield, who was to have a major influence on Henrion's use of the medium. Heartfield not only developed photomontage as an art form but understood its power as a political tool – one which he used in his contributions to the communist publications *Die Rote Fahne* and *Arbeiter-Illustrierte-Zeitung*. But Henrion was to make his own impact with photomontage by skilful experiment and ingenuity. He was in an advantageous position as he had access to the work of official war photographers, many of whom were stationed at the front line. He was even able to use some of their work for his wartime 'commercial' assignments, for example when the parachutists in his POSB *His Needs Come First* poster became be-coated girls parachuting down for W S Crawford's advertising campaign for Harella, the fashion manufacturer.

Henrion's use of photography became a friendly bone of contention with his fellow poster designer Abram Games who considered skills with the airbrush essential to graphic design. Henrion argued forcibly against any attempt to simulate photography: 'I believe it to be fundamentally wrong to imitate the intrinsic qualities of one medium in another. Drawing should give a result that is entirely different from photography and vice-versa.' [6]

Much of Henrion's 'commercial' poster work during the war came through Crawford's, then one of the leading British advertising agencies. But by the end of the war Henrion had built up sufficient reputation for clients to approach him directly and in 1948 he established Studio H.

Henrion was to continue to design posters, notably for the magazine *Punch* and for Philips' Philishave campaigns, but by the end of the fifties Henrion had begun to turn from poster work to

the (for him) more challenging and lucrative field of corporate identity design. Nevertheless he was very ready to take on the odd commission from causes that appealed to his social conscience. From such a motivation he produced some of his strongest images. Of his 1963 *Stop Nuclear Suicide*, with a skull laid over a mushroom cloud, Margaret Timmers, the poster historian, wrote: 'Henrion's design has entered the notorious category of banned posters, as London Transport deemed it contravened its *Conditions Covering the Acceptance of Advertising*. These terms prohibited images which were likely to cause political controversy.'[7]

Although Henrion realised that the poster in the form that he knew it was on its way out, he was concerned that its heyday should be conserved. His own posters are in permanent collections worldwide and, partly through his efforts, the Library of Congress agreed to have in its collection some six hundred posters that had been designed by members of the Alliance Graphique Internationale.

Henrion's other main wartime activity, interwoven with his work on posters, was exhibition design. Again through Landor, Henrion began to be used by the Industrial Design Partnership for their exhibition work for Paris and New York as well as London. His contributions were probably slight, for Henrion makes little reference to these in his later biographical articles. The exhibition for which he described himself as a total novice on a fast learning curve was for the MARS group of architects (Modern Architectural Research) in 1936.

However, Henrion's talent for such three-dimensional design outlets as exhibitions must have been sufficient for Milner Gray to have him as part of his design team when Gray was appointed head of the exhibition division of the Ministry of Information at the start of the war. Henrion soon found himself taking increasing responsibility for the many exhibitions put on by various government departments to educate people as to how to respond to wartime conditions and to keep up morale.

At any time he could be called upon to design exhibitions on any matter – Poison Gas in 1942, Fuel in 1943 – as with posters, he was to design almost all the exhibitions for the Ministry of Agriculture.

14

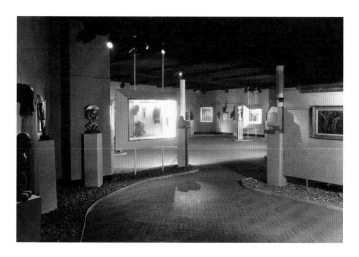

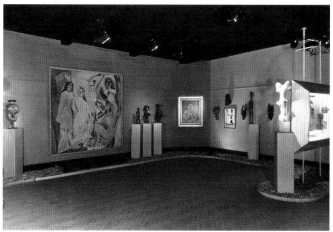

40,000 years of Modern Art, 1948. Henrion turned the unlit basement of the Academy Cinema in Oxford Street, London to his advantage for an Institute of Contemporary Arts exhibition. By borrowing pebble aggregate from the building site next door he avoided the use of barriers. The exhibition included Picasso's *Les Demoiselles d'Avignon* positioned between African sculptures.

However one of his most iconic wartime exhibition designs was not for a government department but for the pressure group Artists International Association in 1942, *For Liberty* extolled the freedoms supposedly being fought for: from want, from fear, of speech and of worship. The siting of the exhibition on the bombed site of the John Lewis department store made it even more striking and poignant. Later in the war, when he was working for the Americans, he designed *Young America* and *US Builds*.

During the forties and fifties exhibition design had a considerable appeal for Henrion as not only did he have a practical bent (he was to produce a number of product prototypes and jewellery), but also perhaps a stronger interest in science and technology than most graphic designers of the time. This helped him in tackling the lighting and security challenges of the exhibition 40,000 Years of Modern Art mounted by the Institute of Contemporary Art in the basement of the Academy Cinema (1948) with its Picasso, *Les Desmoiselles d'Avignon*, amongst other valuable works, and with exhibitions for various manufacturers such as ICI's Whither Chemistry, 1948. Also this work drew on his concerns for design to have a social aspect, an educational dimension.

Henrion's major achievement as an exhibition designer, and the one for which he received his MBE, was the Festival of Britain, for which he was commissioned to design two pavilions – Country and Agriculture. These gave him a marvellous platform not only for his design ideas but also for material experimentation, and were to be a challenge to his managerial skills and patience. A good deal of Henrion's experimentation for his Festival designs centred on the use of plastic, which was relatively new at the time. Ingeniously he used it to encapsulate many of the exhibits, and all the main display letters were cast plastic units embedding a variety of plants, animals and tools. In particular, his emergency putting-together of an artificial oak, when having a living one proved impractical, made the headlines. The tree was some 60 ft high with branches extending some 80 ft. William Feaver, art critic, wrote of it: 'And the Land of Britain, which was decidedly banal at the start, suddenly turned into the Natural Scene, where F H K Henrion's great white artificial oak took over, a stream trickling round its base, ivy scrabbling along its branches. It was a splendid fantasy object.'[8]

The organisational challenges for all the Festival designers were enormous. Henrion, whilst making requisition orders on quintuplicate forms for the thousands of objects he was using, also had to deal with such matters as the necessary daily exercise of the horses in Hyde Park and the constant change of livestock to protect the rare breeds being shown, as well as with organising weekly deliveries of plankton from the Lake District for the fish, and settling disputes between the sweepers and the cowmen as to who should clear the daily dung! All of this was a far cry from designing posters or magazine covers in his studio but was to stand him in good stead for his corporate identity work. His Festival commission brought out the many strengths of his character and the abilities that took him to such heights amongst international designers – high energy levels, practical commonsense, planning and organisational skills, and awareness of client need and budgetary considerations – and all of this in addition to his imaginative ingenuity and aesthetic sense. Henrion, remembering the Festival project, summed up his enjoyment of it all – 'I should not have liked to miss the frustrations and excitement for anything'.

Although Henrion was to be called upon to design several more exhibitions in the early fifties, and a couple more into the sixties, his interests were beginning to take him elsewhere. He designed an eccentric exhibition for the Keep Britain Tidy Group (1964) which the Society of Industrial Artists and Designers' Journal described as 'both a beautiful and moving exhibition as well as a grim and hideous warning' and as 'one of Mr Henrion's finest and brilliant designs'. It had a number of original displays starting with a giant dustbin for the entrance. His most notable international project was for the British Pavilion at Expo 67 in Montreal. For this he was the overall designer of the internal layout but, working closely with the architect Sir Basil Spence and the designer James Gardner, he was to add impressively to the outside with his three-dimensional Union flag atop Spence's tower, and with the ten-foot high lettering around the outside of the pavilion.

In addition to his poster and exhibition work prior to and during WWII, Henrion had a parallel interest in design for print. Just

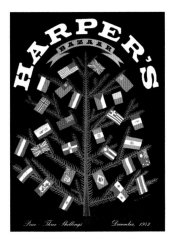
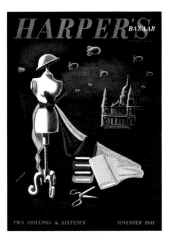
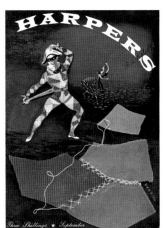
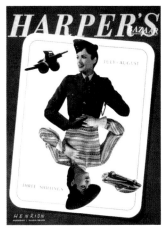

Harper's Bazaar, 1940-1944. In 1940 Henrion took over the job as art director of *Harper's Bazaar* from Edward McKnight Kauffer. Kauffer, an American by birth, had returned to New York. Henrion's morale-boosting covers mixed surrealism with patriot symbolism.

before the start of the war he had begun to contribute to *Vogue* with obvious impact, for in 1940 the then *Vogue* editor was to write to him: 'I understand there is a possibility of you not being able to work any longer here. I do hope this will not be the case as, during the last year, you have got to know our requirements in the illustrative field and if you were no longer available, we should find it difficult to replace you.'[9]

Henrion's departure from *Vogue* was less to do with the onset of war-related design commissions than to the fact that he had been asked to replace the renowned McKnight Kauffer at *Harper's Bazaar* when Kauffer returned to America in 1940. Henrion was to produce covers for this magazine for some four years, after which he was cursorily dismissed, without explanation, via a telegram from *Harper's* owner Randolph Hearst.

Henrion went on to win other commissions from American publishers. His colleagues at the US OWI were not only able to keep him up to date with American graphics but also most likely to provide him with contacts. In 1948 he took over as art director of the Max Parrish magazine *Future*, designing some of the covers himself as well as obtaining prime placement for some of his advertisements for British Aluminium and Shell Chemicals.

He was also, for a brief period, art director of *Contact* published by Weidenfeld. Ashley Havinden, art director at Crawford's Advertising Agency, wrote to Henrion (7 October 1946): 'The make-up, typography, and variety of page treatment are a great improvement on the first issue. The cover I think is very fine, and – I like your quantitative graphic symbols not only on the cover but throughout the production. It was certainly a good idea to have you appointed Art Director.'[10]

From the late forties into the fifties Henrion also got involved in companies' 'house magazines'. He is best remembered for his art directorship (from 1953-57) of the drinks manufacturers W&A Gilbey's *The Compleat Imbiber* which became something of a cult for collectors. Most of the artwork for this Henrion commissioned from other artists, but he did the odd cover and illustration, as for a short story by Laurie Lee.

Henrion did relatively little book design – a few for Max Parrish in the fifties and then a little flurry of work for Penguin in the sixties. Penguin's then Art Director, Germano Facetti, asked him to design a number of covers and some point-of-sale advertising. Given Henrion's interests in the physical and social sciences it may not have been accidental that he provided covers for the *Science and Social Science Survey* books (1965-8). His point-of-sale material had the particularly appealing concept of replacing the 'g' in Penguin with an image of a penguin, which proved both amusing and eye-catching.

Although he was successful in several areas of design he had worked on – posters, exhibitions, magazines – Henrion may possibly already have had the seeds of an idea regarding the focus for his future work as early as 1948 when he wrote an article on 'Design' in the journal *Art & Industry*: 'Designers working for commerce and industry must meet businessmen and industrialists on their own terms and on their own ground. Refusal to do so is sentimental escapism, permissible to artists, or the illustrator, but not to the specialist designer or design consultant.'[11]

He clearly was beginning to line himself up with the latter. In an interview with Mike Barden for the book *Post Early* (1993), Henrion spoke of how his interest in corporate identity design developed: 'Having undertaken exhibition work as well as posters, I diversified out of interest. I became accustomed to doing all kinds of things – stationery, emblems, layouts and packaging. It occurred to me that it would be more sensible to have fewer clients but to be in charge of all their design projects. Luckily, I found the right clients who included Fisons, KLM, and later BEA and Blue Circle.'[12]

What Henrion was talking about came to be known as 'corporate identity' design, which he saw as having two components: *Identification system* – a set of symbols and typographic elements, the purpose of which is to identify the company, and *Design co-ordination* – the development and implementation of a coherent design policy over the whole range of to-be-designed items. It was not enough for the designer to create visually; they had to signal clearly in these visuals the future management ambitions for the organisation; and, additionally, to see that an efficient system was established to ensure uniformity of such designs throughout the organisation.

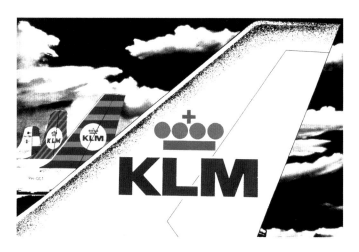

KLM, 1958. Corporate identity for the world's oldest airline still operating under its original name. Henrion wrote: 'A larger corporation can rarely afford to make a sudden and complete break with the past, even if its management wishes to do so. Market research showed that the existing KLM initials, crown and stripes were easily recognised and had goodwill, but were lacking in modernity'.

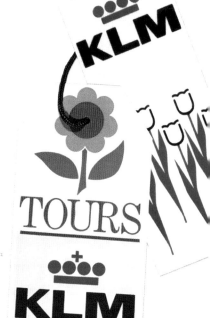

In later years Henrion would claim to have been one of the first, if not the first, design studios to carry out corporate communication programmes in the United Kingdom. Whether such a claim is justified, or even matters, Henrion certainly became a central figure in the field and was to bring out the first textbook on the subject; and Henrion had the strength of personality, the charm and the political astuteness to bring design to board level, for without such endorsement implementation would prove difficult, if not impossible.

His first commission in the field was as early as 1952, from Pest Control (later Fisons). Although done on a shoestring, it gave Henrion his first experience of total design co-ordination from aircraft logo to stationery. It proved to be a massive learning curve that would stand him in good stead for his later more sophisticated and more generously budgeted work with the Post Office and KLM, the Dutch national airline.

Corporate identity design and design co-ordination was 'grown-up' stuff. Apart from its Machiavellian politics it required a diligent intellectual approach – a meticulous detailing of all the design elements involved and a thorough analysis of organisational aims against current design practice and that of the organisations' competitors. How far this was from the then current practice comes across in Henrion's somewhat scoffing description of 'design done piecemeal by clerks, jobbing printers and the last-chairman-but-one'. Henrion felt that in many organisations no one had a full picture of all its design activities, let alone control over them.

The Post Office is a good example of the enormity of the challenge. Henrion did two spells of work with them – from 1965 to 1968 and 1974 to 1979. The complexity of what he unearthed in his initial data collection is exemplified by his discovering that some fifteen different parts of the Post Office were concerned with the design of the telephone kiosk alone; and that pillar boxes, telephone kiosks and stamp machines, adjacent to each other in the street, were controlled by three different departments with no formal channels of communication. Eventually Henrion built up some 1,650 record cards covering some 450 design items and involving 120 key employees (and all of this before the computer was in general use!)

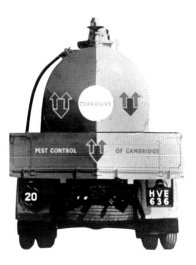

Fison's Pest Control, 1953. One of Henrion's
earliest corporate identity design programmes.
It included stationery, equipment, packaging
and innovative 'split down the middle' vehicles.

Henrion's work with KLM reads as much like scientific research as it does a design project. In dealing with the logo alone he thoroughly tested out some fifteen different versions for impact and legibility. He was able to convince management of the rightness of his solution by putting on film the metamorphosis of his ideas. Eventually Henrion's designs were adopted throughout the organisation from the tail fin of giant jets to the cutlery and glass and luggage labels. The logo was even painted onto the roof of the Queens Park Rangers' football stadium to be seen by passengers flying in and out of Heathrow.

Henrion realised that he would need to strengthen the 'intellectual' element of his studio for his corporate identity work and to achieve this he began his association with Alan Parkin, a Cambridge 'logical mathematician'. With Parkin, Henrion wrote what was to be his philosophy on the subject, as well as being a practical handbook, *Design Coordination and Corporate Identity* (1967). Although today much of this reads as commonsense, to the run-of-the-mill graphic designer working on ephemeral press advertisements in the late sixties its impact must have been monumental.

Corporate identity work not only led Henrion into his complementary relationship with Parkin but also made him adopt a more delegatory style in his studio as the work meant a long-term commitment to the commissioning organisation. This was particularly brought home to him when one of his corporate clients took out a life insurance policy on him!

Henrion felt strongly that a mature designer had a professional duty to impart their experience to the next generation; that teaching design was not merely a way of supplementing one's income but of bringing the actual reality of design practice to the often idealistic student. He was to take on a variety of roles as an educator – lecturer, head of department, external assessor, governor and membership of educational policy working parties. David Gentleman remembers him as a visiting lecturer at the Royal College of Art in the early fifties: 'He brought to teaching … both a Gallic elegance and a commercial confidence, a whiff of brimstone in the Victorian revival atmosphere of the College.'[13] Gentleman described Henrion's teaching as combining charm

and encouragement with being 'sharply exacting if anyone was sloppy or lazy'. He confronted the students with the hard facts of designing for advertising with practical projects and managed to attract some of them to advertising as a career, which was still considered rather 'infra dig'.

In England, as an educator Henrion was to work with Manchester, North East London and Leicester Polytechnics, with Canterbury and West Sussex Colleges of Art and, most significantly, with the then titled London College of Printing. In 1975 Tom Eckersley was retiring as the Head of Graphic Design at the College after some sixteen years and he sought Henrion out to ask him to take over. Although at first hesitant, Henrion agreed to head up what was to become the Faculty of Visual Communication. In the archives is a discussion document drawn up by Henrion in which he lists the knowledge and skills he saw as necessary for a graphic design graduate to achieve. Given the date, 1977, it is a remarkable credo for its advanced emphasis on the community and environmental aspects of design and its concern that designers should be 'well-educated' so that in their problem-solving they could draw upon knowledge of science and engineering, social and mathematical sciences and even philosophy, where relevant.

In stressing that mind, hand and heart should all be considered Henrion was perhaps harking back to Richard Guyatt's contribution to *The Anatomy of Design*, the credo of the then Professors at the Royal College.[14] What Henrion wanted for design students was 'intuitive freedom with pre-planned disciplined precision'. But all of this was spiced with fun: 'I know that design is an exciting challenge. This excitement must start at college, from the Foundation course onwards, and with luck it will be experienced by each graduate throughout his/her professional life.'[15]

Henrion's international dimension came out in his education work as well as in his consultancy. Not only did he lecture worldwide but he is particularly remembered for the student seminars he organised for the International Council of Graphic Design Associations (ICOGRADA). For these he invited distinguished European and American designers to show and explain their work. Unabashed he hired the Odeon, Leicester Square as his UK seminar

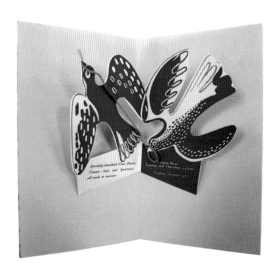

Pop-up cards, 1930s. An invitation, above, for a
made-to-measure knitwear company, the 'early
birds' carrying a woollen thread worm, and below,
knee jerks for a Parisien *trainer individuel*.

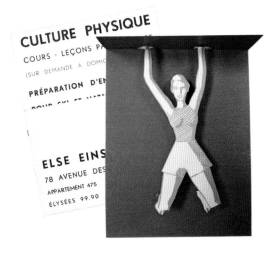

venue. Within a few years over 1,000 students were attending. Henrion ran these seminars for some seventeen years, and their popularity was such that they were continued by Alan Fletcher and Henrion's widow, Marion, for a number of years after his death.

Henrion gave a good deal back to the profession that had given him so much. In his presidential address to the Society of Industrial Artists and Designers (now the Chartered Society of Designers) he stated his position: 'No individual can practice a profession alone. His judgements, however excellent, represent no more than his personal tastes and experiences. A reliable professional standard is always the fruit of shared experience and gives to all individual practitioners the support of a well-tempered tradition.'[16]

In the same address Henrion pointed out that professional status did not only give prestige but implied responsibility; and he certainly did not shirk from this either nationally with the Society of Industrial Artists and Designers (SIAD) or internationally with his work for the Alliance Graphique Internationale (AGI) and for ICOGRADA. Of Henrion's SIAD contributions James Holland wrote: 'No name occurs more frequently, nor in such a variety of contexts than his. To maintain an unflagging critical interest in all aspects of SIAD activities over such a long period is a remarkable achievement, and happily there is not much doubt that this concern and interest is by no means exhausted.'[17]

Henrion's contributions were acknowledged when, in 1976, he was awarded the SIAD design medal – an annual gift to a designer of outstanding achievement. Nominations for this could be made worldwide and this was especially important to Henrion for whom the approbation of his colleagues was paramount.

His contribution to AGI was even greater and as this was an elected 'elite' body of those making a significant contribution to graphic design, this again was a matter of peer approval. As with SIAD Henrion's contributions were various but his major work, and indeed his swansong, was his researching and compiling of the *Alliance Graphique Internationale – 1952-1987*. This massively impressive work took him some five years to complete, throughout which he was battling with cancer. In taking on the task Henrion compared

himself with Vasari – 'I readily promised to do it as best I could, for I knew it was really beyond my powers'. In that Henrion was given a free hand, the book became a vehicle not only demonstrating his considerable erudition, but also one in which he could bring together his own thoughts as to where design had been and where it might be going. It has become an essential text for students of twentieth-century design history, and justifiably so.

Henrion's numerous obituaries repeatedly mentioned his 'people side' – not only his personal charm and sociability but his humanity and social conscience. Both in his teaching and in his consultancy he urged an awareness of the social context of design; that designers were at their finest when dealing with issues of humanitarian significance, and that each designer should face their own conscience when taking on a commission.

Then he was remembered for his intellectual approach to design: the importance of a broad cultural background and the necessity for prior thinking and data collection before the drawing board was approached, yet that 'research should not dull creativity'. In his 1962 presidential address to SIAD he makes this quite clear: 'The vocation of a designer is essentially at root the same as that of the artist. But unlike the artist who has largely cut himself off from Society, the designer has to function within the limitations imposed by Society. Whereas the artist works to self-imposed limitations, the designer accepts those imposed from outside, by the commissioning body, and the specific problem he is called upon to solve. But this difference is only one of degree … The good designer has to please himself as well as his client'.[18]

But beyond all other qualities Henrion is remembered for his energy and his obsession with design. His widow, Marion, wrote of him as 'congested with visual ideas'. She described his ability to concentrate irrespective of what was going on around him, totally focussed on the blank piece of paper in front of him – whether at his desk, at a garden table, or nude in a dinghy in the pool.[19]

John Halas summarised Henrion's head, heart and hand qualities neatly: 'It is not difficult to detect Henrion's anatomy vertically. On the top a well-tuned up brain, motivated by intellectual and

practical considerations. Proceeding downwards, good intentions, remembering the interests of all concerned, including clients and the younger generation, as well as the overall influence of his work on society. Continuing downwards he has steady feet, standing up for over 50 years to the battles and fights that often occur in this profession.'[20]

Henrion, as a designer, had the imagination to embrace future possibilities yet respect and draw from the past. He embraced his fellow men yet had the ego strength to carve his own career as he wished. He was one of the most 'Renaissance' of men amongst British twentieth-century graphic designers for some fifty years.

1 F H K Henrion, 'How F H K Henrion designer, became HDA International' article, unspecified journal, Henrion Archives.

2 F H K Henrion, 'A little scandal in the street', *Penrose Annual*, Vol. 63, 1970.

3 Mike Barden, *Post Early, GPO Posters 1920-1960*, Camberwell Press, 1993.

4 Letter from Central Office of Information (24.6.46), Henrion Archives.

5 Letter from Post Office (20.9.40), Henrion Archives.

6 As quoted in Naomi Games et al. *Abram Games, Graphic Designer, Maximum Meaning, Minimum Means*, Lund Humphries, 2003.

7 Margaret Timmers (ed.), *The Power of the Poster*, V&A, 1998.

8 William Feaver, 'Festival Star' in *A Tonic to the Nation*, Thames & Hudson, 1976.

9 Letter dated July 1940, Henrion Archives.

10 Letter from Ashley Havinden (7.10.46), Henrion Archives.

11 F H K Henrion, 'Design', *Art & Industry*, 1948.

12 Mike Barden, *Post Early, GPO Posters 1920-1960*, Camberwell Press, 1993.

13 David Gentleman, *The Guardian*, (7.7.90).

14 Richard Guyatt, 'Head, Heart & Hand', *The Anatomy of Design*, The Royal College of Art, 1951.

15 Contribution to the London College of Printing Magazine (15.2.77).

16 'Presidential Address', *SIAD Journal*, April 1962.

17 James Holland, *Minerva at Fifty, the Jubilee History of the Society of Industrial Artists & Designers 1930 to 1980*, Hurtwood Publications Ltd, 1980.

18 'Presidential Address', *SIAD Journal*, April 1962.

19 'Design as a Way of Life', *AGI: Graphic Design since 1950*, Ben & Elly Bos, Thames & Hudson, 2007.

20 John Halas, *Form*, 1989, Henrion Archives.

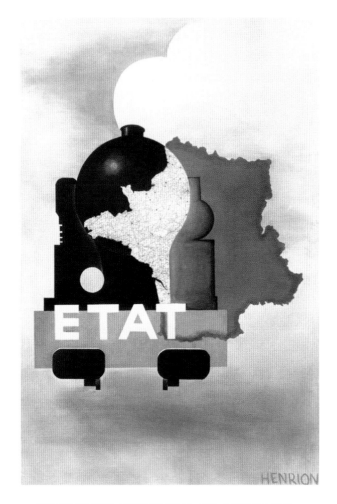

Etat (East) 1934. Poster for the Chemin de Fer de L'Etat designed as a project while Henrion was a student at the Ecole Paul Colin. The locomotive emerges from a silhouette map of France. The poster was redrawn by Henrion for a retrospective exhibition of his work in 1989.

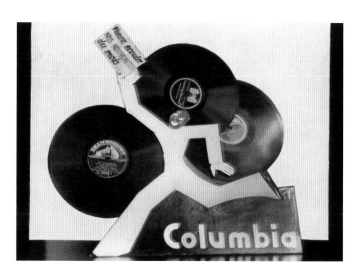

Display stand design for Columbia Records, c.1934. A project incorporating a 'Jazz Age' figure. Both this and the *Etat* poster illustrate the influences of A M Cassandre, who designed many now famous posters for Pathé and Chemin de Fer du Nord and other railway companys, including the London Midland and Scottish Railway in the 1920s and 1930s.

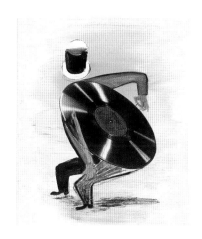

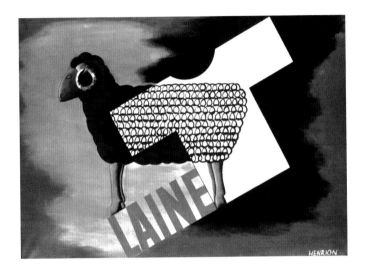

Laine, 1934. Poster design demonstrating wool from raw material to finished product and opposite, poster design, 1934 for the raincoat manufacturer Match demonstrates the superior quality of their *Imperméables* against the driving rain. Both these student projects now only exist as black and white photographs.

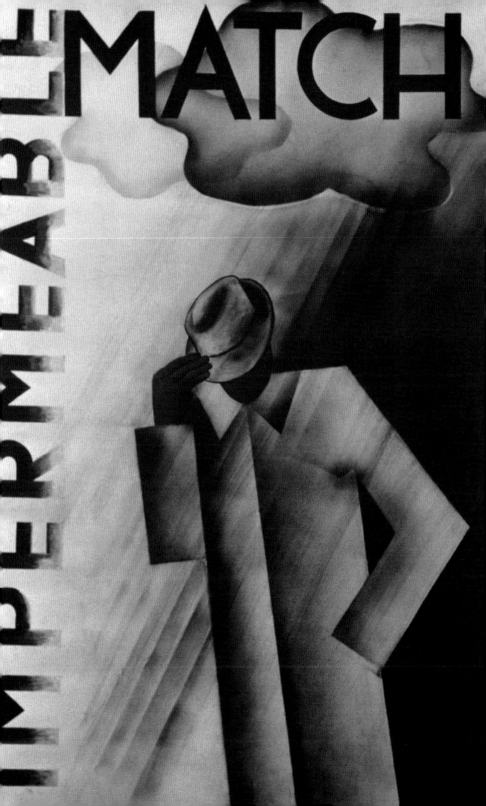

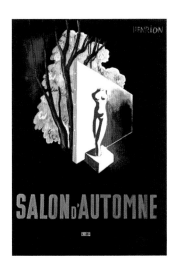

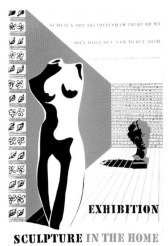

Posters, 1930s. The *Salon d'Automne* for the 1934 exhibition at the Grand Palais, Paris and *Sculpture in the Home*, Heal's Art Gallery exhibition. Posters combine favourite Henrion 'sculptural torso' devices against dramatic perspective. Henrion also used the classical head, with zodiac symbols, as a leaflet cover in 1937 for Roussel Laboratories, London.

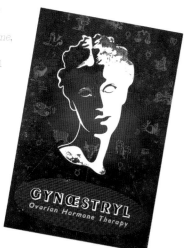

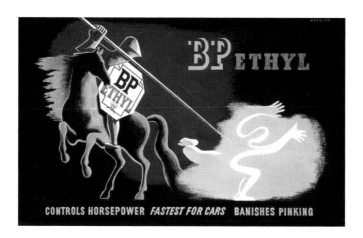

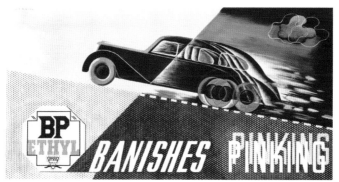

BP, 1938. Unpublished poster designs commissioned by Jack Beddington, Shell and BP's legendary advertising manager, who during the war worked for the Ministry of Information. The posters show the influence of McKnight Kauffer, one of Shell's most prolific poster designers.

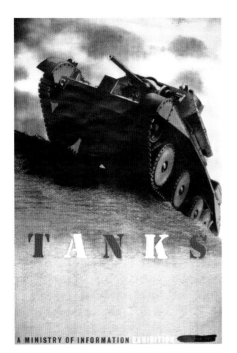 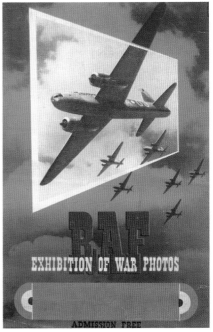

Ministry of Information, 1941-42. For *Tanks*, Henrion photomontaged the foreground scene and the tank together. As no fully finished tanks were available he added the turret and the gun barrel. For *The RAF Exhibition of War Photos*, individual bombers were montaged into a squadron with the leading plane framed as a photographic print.

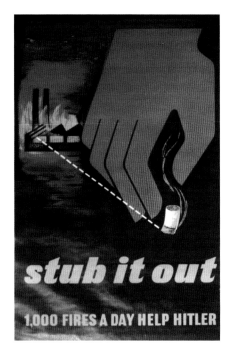

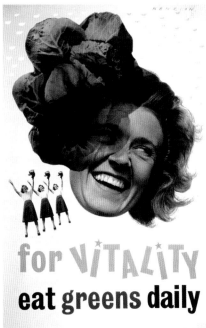

For *Stub It Out*, Henrion demonstrates 'cause and effect'.
The 'Henrion hand', another favourite device, is stubbing out a
cigarette linked to a burning factory. In *For Vitality Eat Greens
Daily* he ventures into surrealism; a killer cabbage supported
by cheerleaders is about to devour the young woman. The poster
was printed but not used, being considered too humorous!

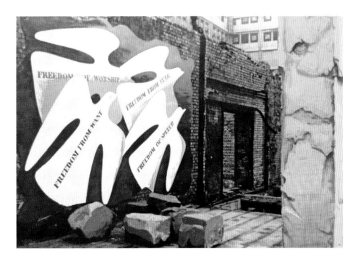

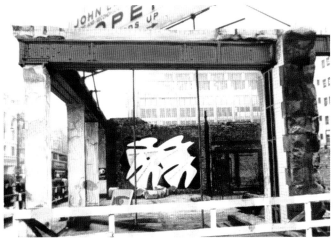

For Liberty Exhibition, 1942. Designed on behalf of the Artists International Association, the exhibition was held in the air raid shelter of the blitzed John Lewis department store in Oxford Street, London. Henrion incorporated the bombed structure, picking out girders in red and yellow, into the exhibition.

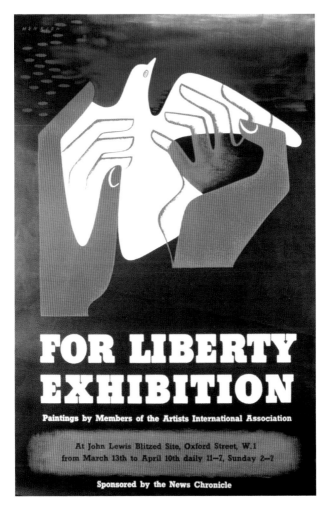

Paintings by British and refugee artists, including Michael
Rothenstein, Oskar Kokoschka, Augustus John, Ruskin Spear
and John Tunnard, express 'The Four Freedoms': freedom of
speech, freedom of worship, freedom from fear and freedom
from want.

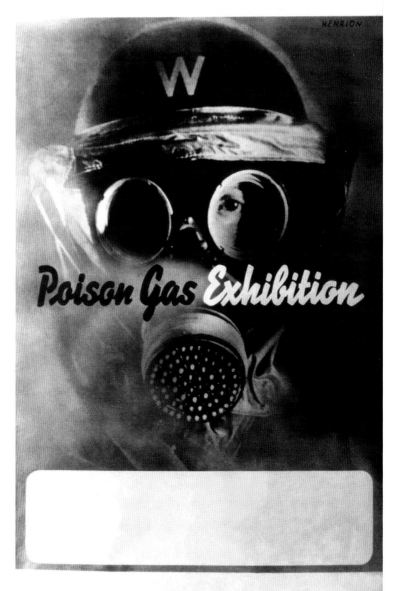

AN M.O.I. EXHIBITION PRODUCED ON BEHALF OF THE MINISTRY OF HOME SECURITY ADMISSION FREE

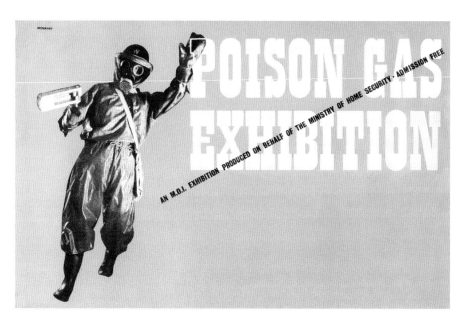

Poison Gas, 1941. Posters for the Ministry of Home Security. Opposite, an ARP (Air Raid Precautions) warden wearing helmet and mask emerges from a swirling mist of gas. (The blank panel would be overprinted with exhibition venues and dates). The figure, above, in the gas protection suit and carrying an alarm rattle, was the chief air raid warden for Holborn who stood on a desk in his office for Henrion to draw and photograph him.

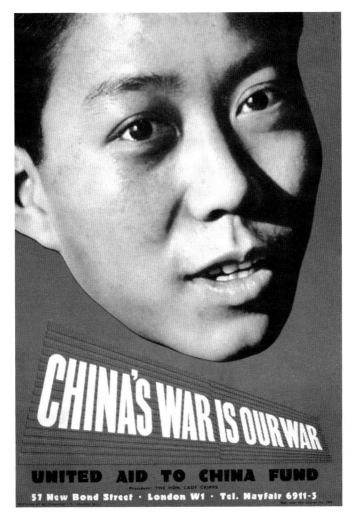

China's War is Our War, 1942. Photographic image
and dramatic type for the United Aid to China Fund.

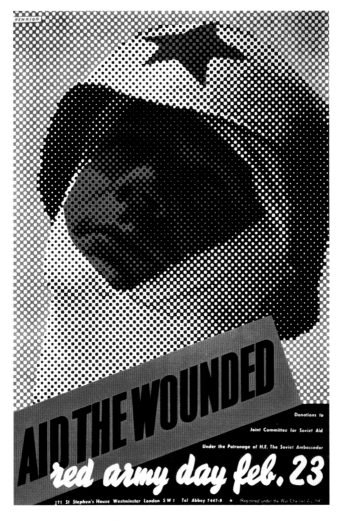

Aid the Wounded, 1942. Enlarged half-tone dot photograph of
a bandaged Soviet soldier for the Joint Committee for Soviet Aid.

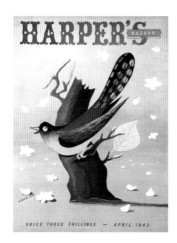

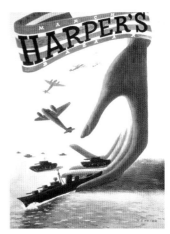

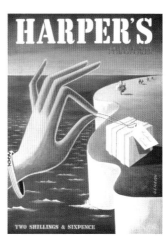

Harper's Bazaar, 1940-1944. Between 1940 and 1944 Henrion produced 24 covers for *Harper's Bazaar*. With the end of the war in sight, Randolph Hearst, *Harper's* owner sent a telegram: 'stop Henrion covers'.

Original drawings, 1942-45. Commissioned by
the advertising agency W S Crawford for the Ford
Motor Company. The press campaign illustrated
post-war concepts of Britain's future.

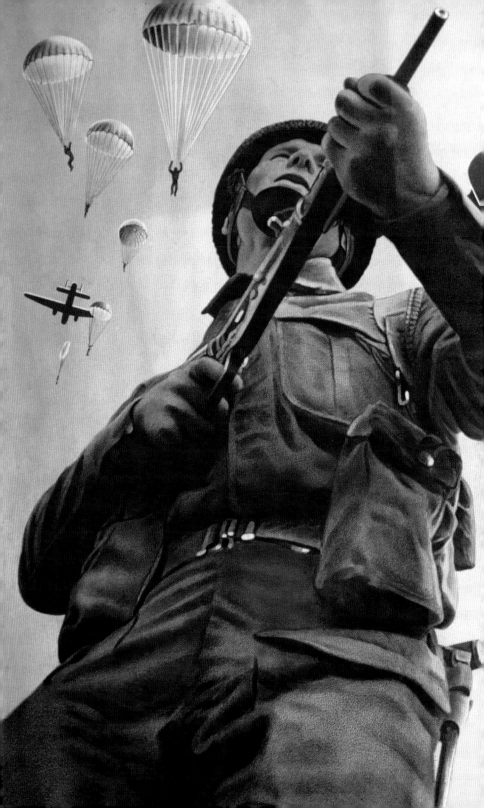

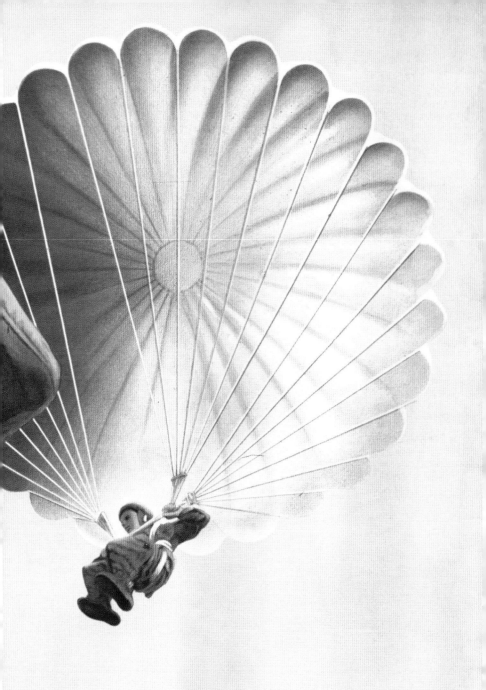

needs come first: Lend - don't spend

ST OFFICE SAVINGS BANK

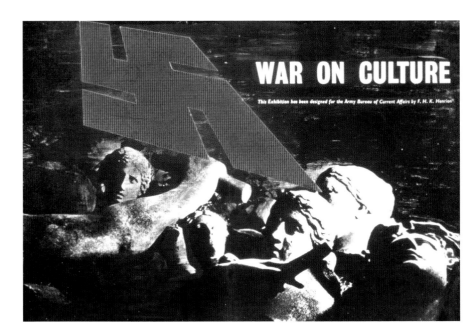

WAR ON CULTURE

This Exhibition has been designed for the Army Bureau of Current Affairs by F. H. K. Henrion

War on Culture, 1943. An unused poster design for the Army Bureau of Current Affairs. The original photomontaged artwork shows destroyed classical sculptures in black and white under attack from a knife-like red swastika.

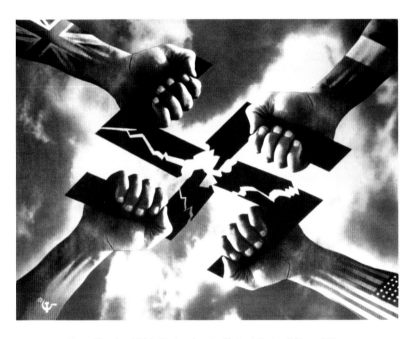

Four Hands, 1944. Poster for the United States Office of War Information designed, before the date of D-Day was known, to be shown in Europe after D-Day. The united hands of the Allies tear the swastika apart. No words are required.

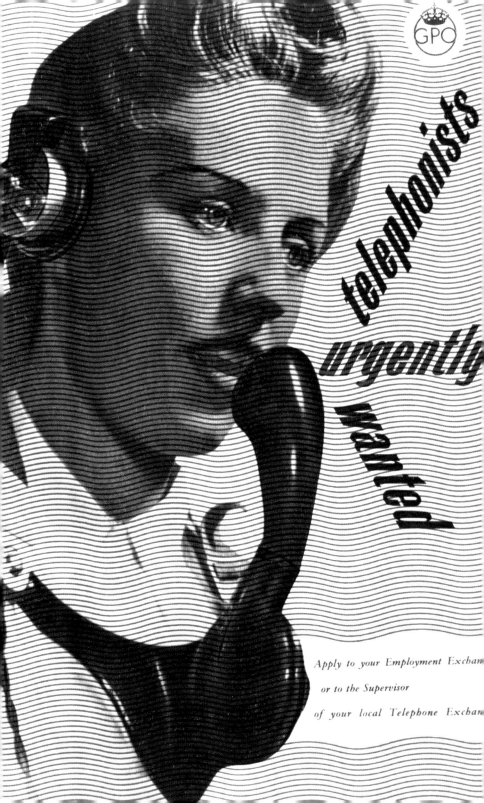

GPO

telephonists urgently wanted

Apply to your Employment Exchan
or to the Supervisor
of your local Telephone Exchan

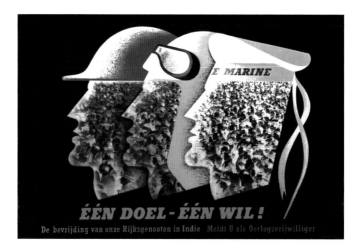

ÉÉN DOEL - ÉÉN WIL !

De bevrijding van onze Rijksgenooten in Indie Meldt U als Oorlogsvrijwilliger

Telephonists Ugently Wanted. Opposite, wartime recruitment poster for the GPO, adapted from an earlier poster *We're in it Together.* Henrion was at the same time working for the Ministry of Information and Crawford's advertising agency in the evenings. Henrion claimed that, unlike the master airbrush craftsman Abram Games, he could 'never achieve more than a splatter.' Rather than using airbrushed portraits he was able to make use of official war photographers. In *Één Doel – Één Wil! (One Aim – One Will)*, 1944, above, he photomontaged civilians under the helmets and hats of Dutch soldiers, airmen and sailors. Recruitment poster for the Dutch government in exile.

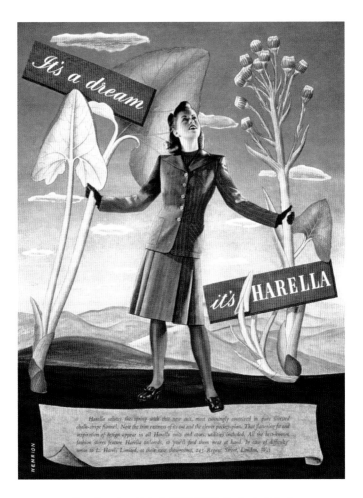

Harella advertising, 1942-1946. Commissioned
by W S Crawford. The surreal *It's a Dream*
advertisements appeared from 1942 to 1946.

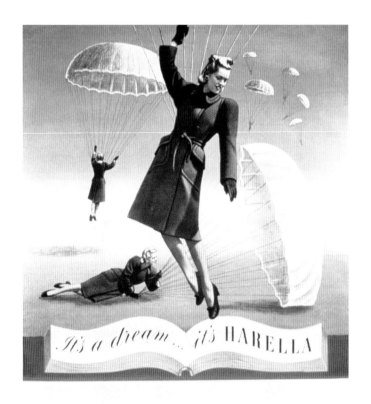

Henrion directed the photographs by Nancy Sandy-
Walker, which were hand-coloured and montaged
with old engravings and painted backgrounds.

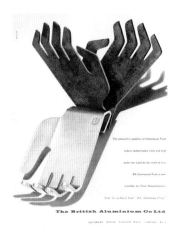
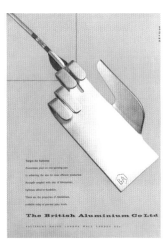
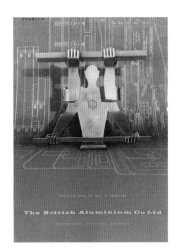
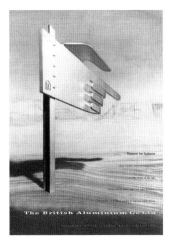

The British Aluminum Company, 1947. *Make One Hand do the Work of Two, Target for Industry, Aluminium Raises the Level of Production* and *Signpost for Industry,* the material is the message, advertising campaign.

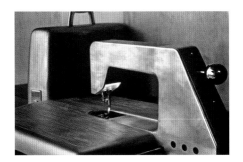

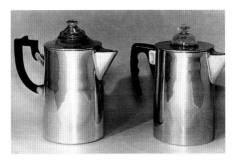

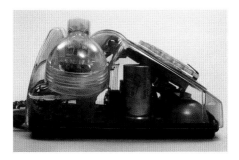

Prototype aluminum portable sewing machine, designed for the Britain Can Make It exhibition, 1946; before and after designs for a coffee percolator, 1948; prototype transparent telephone, 1968, for the Post Office.

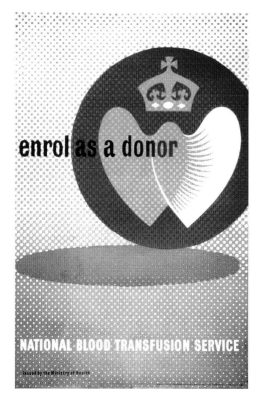

National Blood Transfusion Service. In 1947 the
Design Council held a competition to design a
new symbol to be used on donors' medals for the
National Blood Transfusion Service. Henrion's
'hearts' design won and was later used in
publications. When the service was granted royal
patronage Henrion was asked to add the crown.

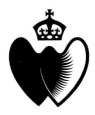

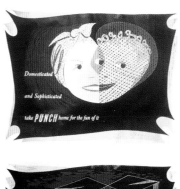
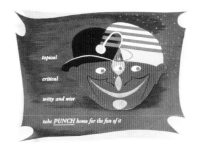
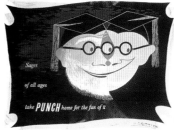
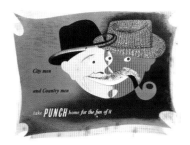
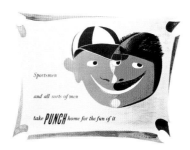
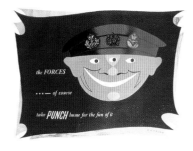

Take Punch home for the fun of it, 1948.
Poster campaign for *Punch* magazine designed
to be used on the London Underground.

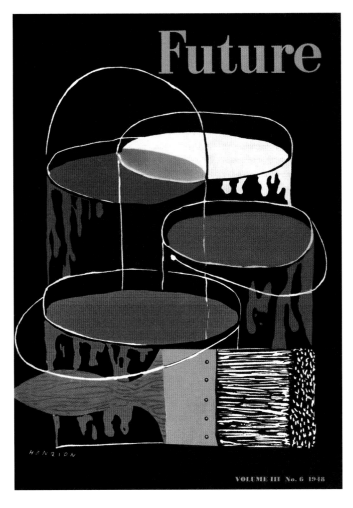

Future, 1948-50. Henrion was an editorial consultant and frequent cover designer for the magazine. Inside, articles were

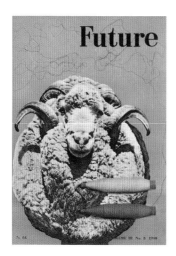

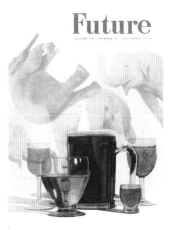

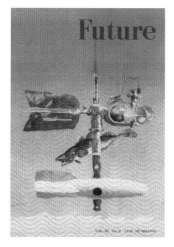

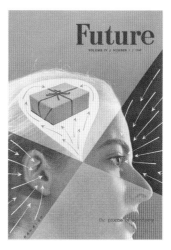

illustrated by John Minton, Lewitt-Him, Julian Trevelyan,
Barbara Jones, Hugh Casson, Abram Games and Isotype.

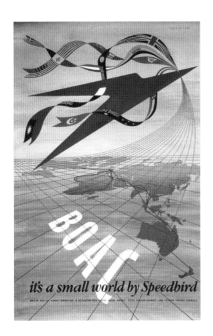
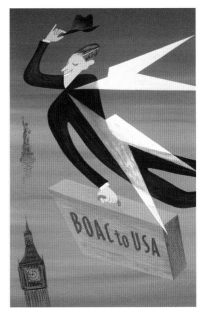

Posters for BOAC, 1947. From a series commissioned by the London Press Exchange advertising agency as part of a campaign to promote post-war travel. The 'Speedbird' designed by Theyre Lee-Elliot in 1932 as the symbol for Imperial Airways, BOAC's predecessor, became the title of the company's house journal, opposite, art directed by Henrion in the 1940s.

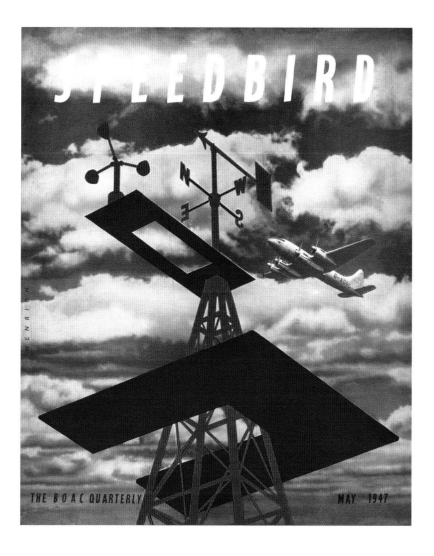

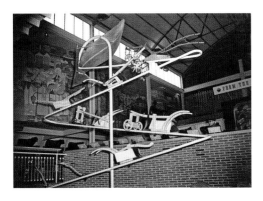

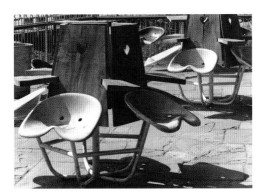

Festival of Britain, 1951. Henrion was responsible for the design of the Agricultural and the Country Pavilions. For the six-month duration of the exhibition, livestock and plants

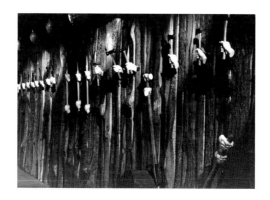

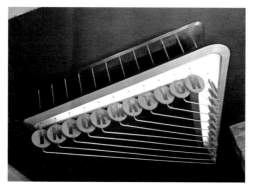

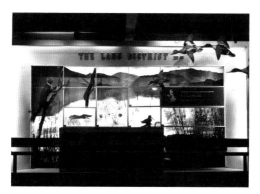

had to be restocked and cared for. Seating
for the terrace Milk Bar was created from
tractor seats and sculptures commissioned
from Henry Moore and FE McWilliam.

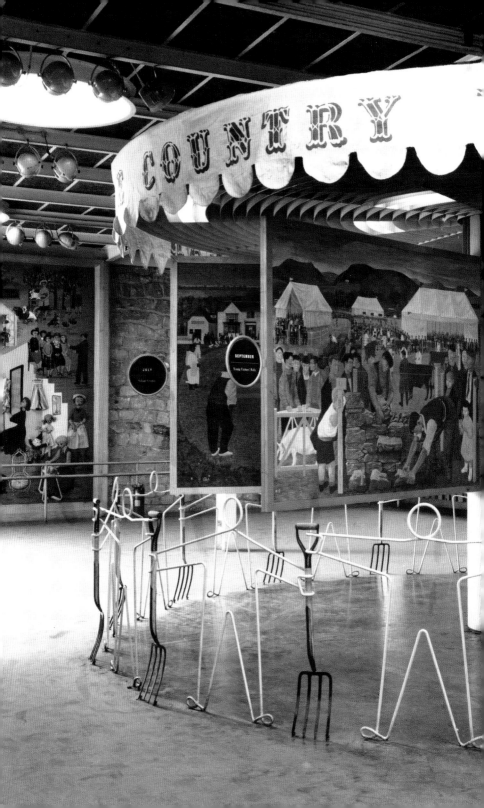

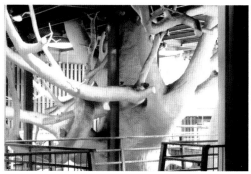

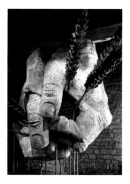

The Country Pavilion was built before the
planned live 60 ft high tree could be positioned.
Henrion's solution was to build an artificial tree.
With a spread of 80 ft, the exhibit was designed
around it. The bent wire figures around the
Country Year display hold real garden forks.

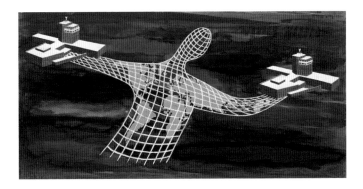

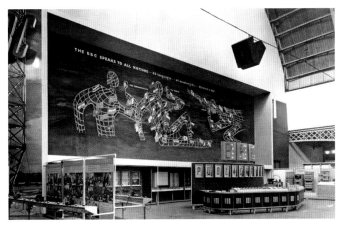

Taylor Woodrow built this airport, 1955. Poster
artwork for a wireframe figure which encapsulates
a world map, holding two airport terminals in
outstretched arms and hands and, above, further
wireframe figures for a BBC exhibition.

Bowaters, 1949. The first of Henrion's many corporate
identity projects. The design of the company symbol
for the paper manufacturer Bowater Corporation is
based on a 'B'-like bow and water rebus.

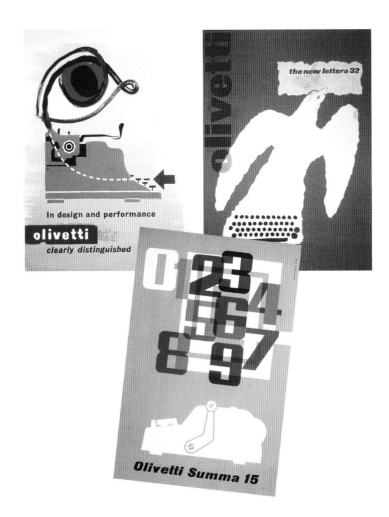

Olivetti, 1960s. Posters and advertising for typewriters and adding machines for British Olivetti. The company had a factory in Glasgow in the 1960s.

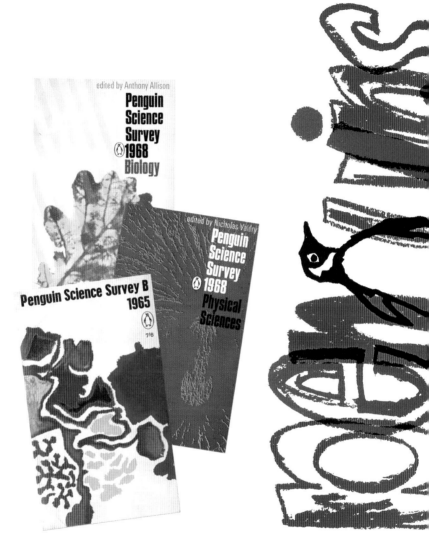

Penguin Books, 1960s. *Science Surveys* commissioned by Germano Facetti. The Penguin logo substitution for the 'g' became a popular and long lasting image.

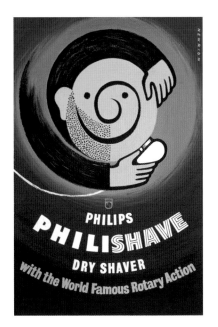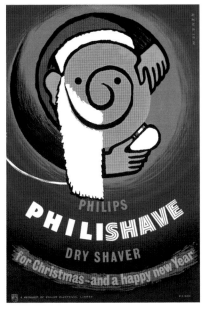

Philips, 1955-1957. The Philishave rotary man was commissioned by the Erwin Wasey advertising agency as a series of billboard posters. Henrion emphasised the shaver's rotary action with concentric type. The Philishave man could be adapted to suit the message and the season; he became Father Christmas, and later grew into an advertising campaign in *Life International*. The advertising headlines are based on Cole Porter's 'Let's Do It'.

Danes use it
Diggers on Australian plains use it
Passengers in transcontinental
trains use it

PHILIPS PHILISHAVE

Burmese use it...
men on skis use it...
twentieth century Cherokees use it...

Americans (lots) use it
Millionaires on yachts use it
Extraordinarily canny Scots use it

PHILIPS PHILISHAVE

Malays use it...
Stars in American plays use it...
Toreadors who get the most
olés use it...

Hawaiians use it...
Paraguayans use it...
He-men hunting for lions use it...

Maltese use it...
eminent Burmese use it...
Australians taking their ease use it...

Norwegians give it
American collegians give it
Leading inhabitants of
Polar regions give it

PHILIPS PHILISHAVE

Knights use it
Acrobats in tights use it
V.I.P.s on International flights use it

PHILIPS PHILISHAVE

French thinkers use it...
Swiss ice-rinkers use it...
Gentlemen whose ancestors were
Incas use it...

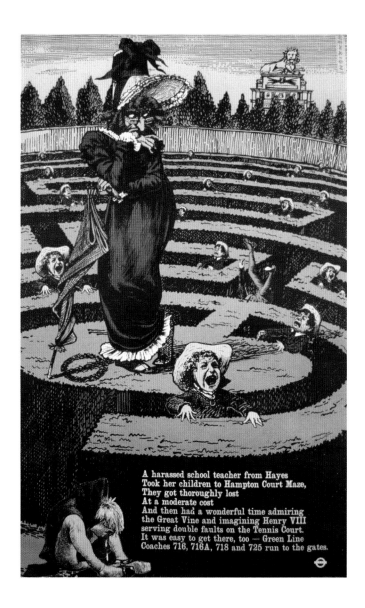

A harassed school teacher from Hayes
Took her children to Hampton Court Maze,
They got thoroughly lost
At a moderate cost
And then had a wonderful time admiring
the Great Vine and imagining Henry VIII
serving double faults on the Tennis Court.
It was easy to get there, too — Green Line
Coaches 716, 716A, 718 and 725 run to the gates.

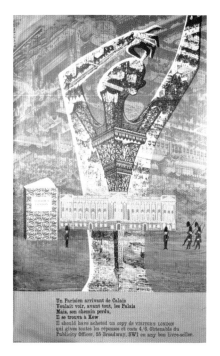

Un Parisien arrivant de Calais
Voulait voir, avant tout, les Palais
Mais, son chemin perdu,
Il se trouva à Kew
Il should have acheted un copy de VISITOR'S LONDON
qui gives toutes les réponses et costs 4/6. Obtenable du
Publicity Officer, 55 Broadway, SW1 ou any bon livre-seller.

A psychology pstudent of Pstaines
Psaid his ego was pshattered by trains
Pso he took it to psee
The psceremony
Of Changing the Guard which takes place every morning
at the Horse Guards and on most mornings at
Buckingham Palace or St. James's. All the details
are contained in a leaflet, obtainable free from the
Publicity Officer, London Transport, 55 Broadway, S.W.1.

London Transport, 1957. For *A Harrassed School Teacher*,
his collaged and vibrantly coloured Green Line Coaches
poster, Henrion borrowed figures from Lewis Carroll's *Sylvie
and Bruno*. For *Un Parisien Arrivant de Calais*, upside down
engravings of Paris and the Eiffel Tower make the figure of
the French tourist. The *Visitor's London* next to Buckingham
Palace has a cover design by Edward Bawden. For the
Psychology Pstudent from Pstaines Henrion used railway
images to create the Pstudent who is being haunted by the
shadow of a locomotive.

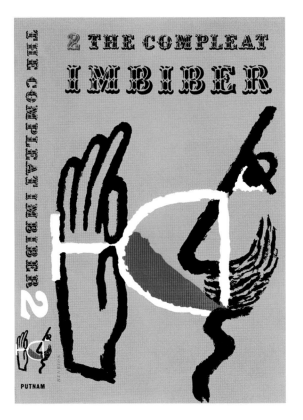

The Compleat Imbiber. From 1953 to 1957 Henrion was art editor of W&A Gilbey's house magazine. The aim was 'to establish an atmosphere of comfort and warmth, with a strong period flavour to suit the title, without losing a contemporary and topical note'. The magazine's masthead is set in 'Fairground' transfer lettering, one of a series of 20 alphabets compiled by Henrion for Letraset Limited.

A A A A A

D D D D D

G G G G G

I I I I J J K K K

N N N N

O O O P P P P

S S S

U U U V V

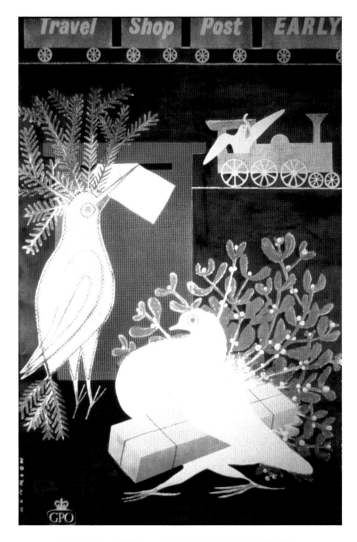

Post Early, 1953. A seasonal reminder from the GPO
to post early for Christmas. The early bird, driving
the nineteenth-century engine, got the worm.

AT THE COUNTER FOR PACKING LEAFLET

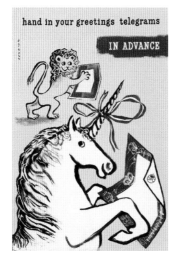

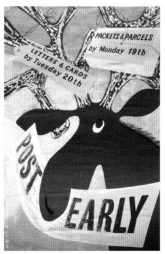

More gentle reminders from the GPO, 1950s.
The unicorn above left, 1953, holds a coronation
greetings telegram.

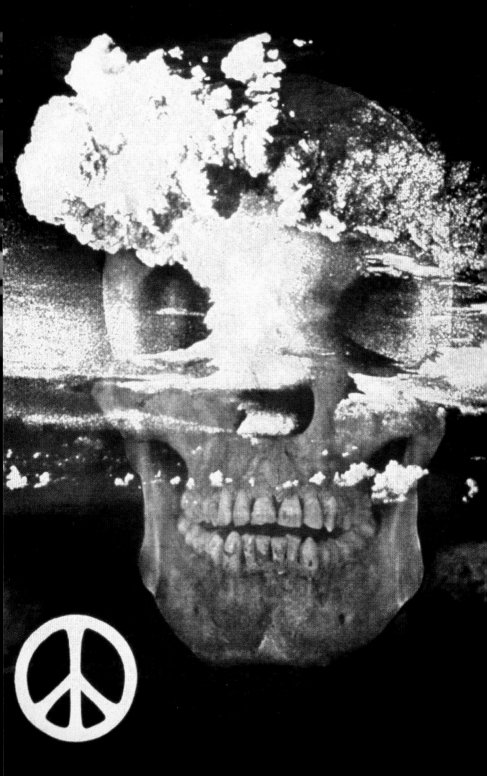

STOP NUCLEAR SUICIDE CAMPAIGN FOR NUCLEAR DISARMAMENT 2 CARTHUSIAN ST LONDON EC

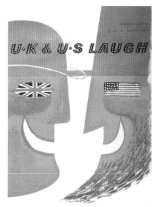

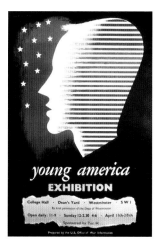

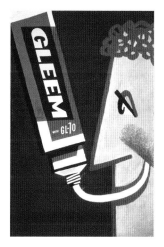

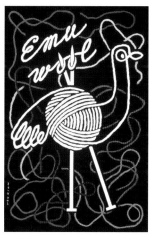

Campaign for Nuclear Disarmament, 1960. Opposite, first shown at the Institute of Contemporary Arts, Henrion's CND poster *Stop Nuclear Suicide* was refused by London Transport as too disturbing.

Posters from the 1940s and 1950s. Above, *UK & US Laugh* posters for an exhibition of *New Yorker* and *Punch* artists' works, and *Young America* sponsored by TOC H. *Gleem* and *Emu* were for the advertising agency Erwin Wasey. *Gleem* was rejected by the client, Proctor & Gamble, who wanted a poster as part of a press and TV campaign. Henrion realised it was the end of what he called 'the ideas poster'.

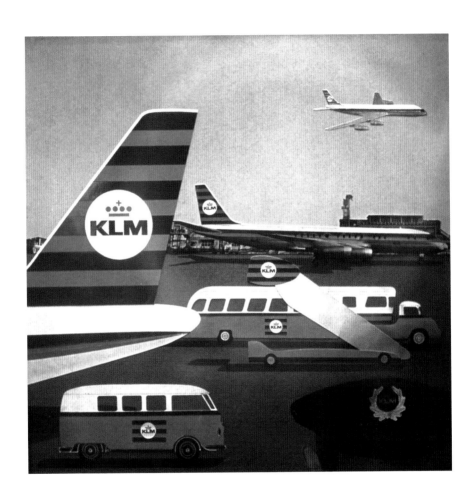

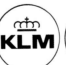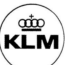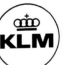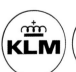

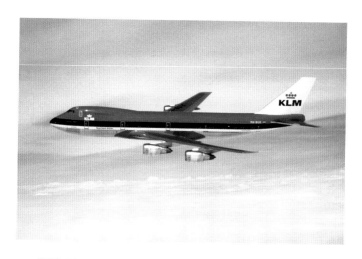

KLM, 1958 and 1965. The new corporate identity designs proposed making the existing elements stronger and more flexible. The crown was subjected to lengthy testing against poor viewing conditions, distance, movement, sharp angles and low attention span before final approval. In 1965 Henrion was asked to review the identity for the jumbo jet era. He was able, this time, to drop the stripes and rely on the now well established lettering and crown on a white background.

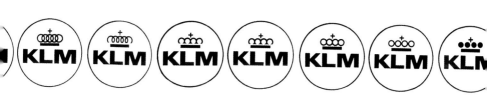

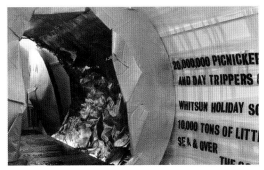

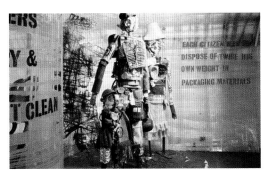

The Message-Age exhibition, 1964. Commissioned by the Keep Britain Tidy campaign. Henrion used students from the Royal College of Art, where he was teaching, to collect rubbish from London streets.

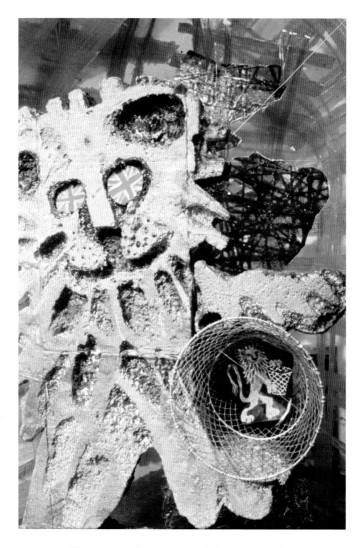

The resulting litter was recycled to create male and female figures and displays, and crates stacked to make display panels. The main feature was a giant walk-through dustbin.

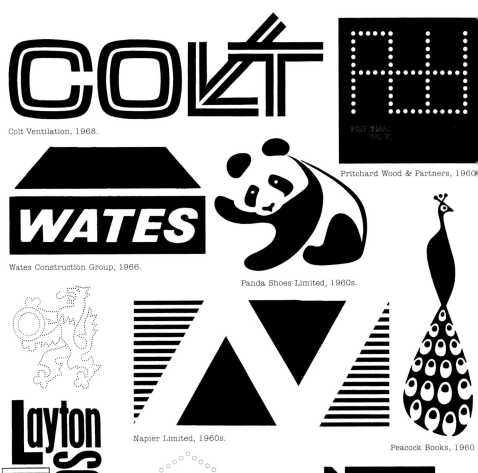

Colt Ventilation, 1968.

Pritchard Wood & Partners, 1960

Wates Construction Group, 1966.

Panda Shoes Limited, 1960s.

Napier Limited, 1960s.

Peacock Books, 1960

Layton Annual Awards, 1962.

Metra Group, 1960s.

Square Grip Reinforcement Company, 1960s.

Glasgow Railway Electrification Service, 1967.

Rapp Metals, 1960s.

BROOKS
BROOKS
BROOKS
VENTILATION

Brooks Ventilation Units, 1960s.

Arthur Sanders, 1960s.

International Wool Secretariat, 1960s.

Molins Machinery Limited, 1960s.

NT'S
NATIONAL
THEATRE

National Theatre, 1971.

Simplex Piling, 1961.

Allied Breweries, 1960s.

Cox of Watford Limited, 1963.

Royal Festival Hall, 1950.

Cunard, 1950s.

Associated Industrial Consultants, 1960s.

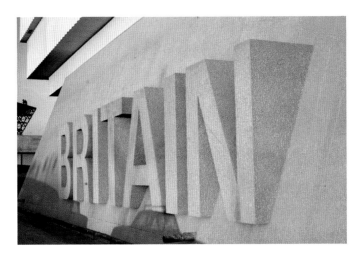

Expo 67, Montreal. Working in collaboration with the architect Sir Basil Spence. Spence had intended that the tower would remain incomplete as a symbol of Britain's unfinished potential. Henrion by chance placed a Union flag on the top of the tower, and ... the rest is history.

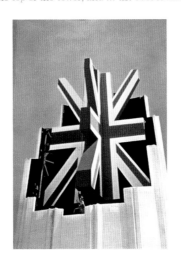

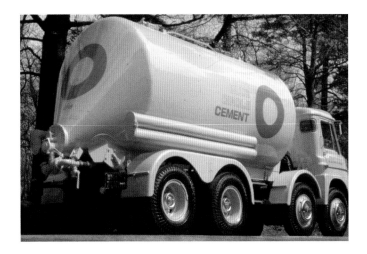

Blue Circle, 1968. The result of the grouping together of more than 20 allied companies. Beginning as the Associated Portland Cement Manufacturers in 1900 and growing into the largest cement manufacturer in the world. The name Blue Circle was selected to apply to 2,000 road vehicles, 800 railway wagons, and 300 varieties of sacks, drums and tins.

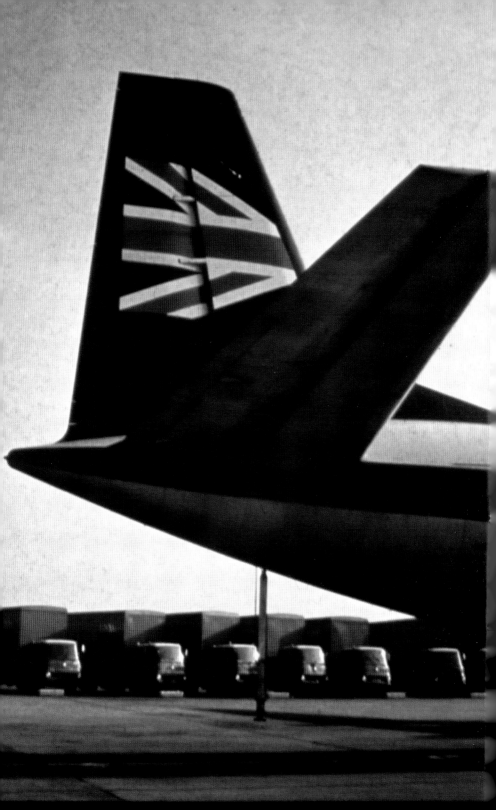

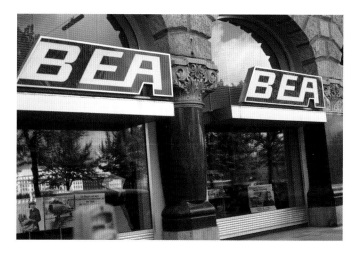

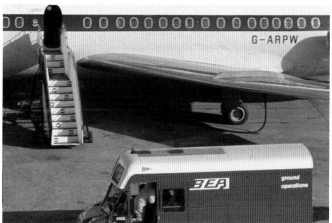

BEA, 1970. Before the introduction of British Airways – the merger of BOAC and BEA – the company's planes and ticket offices were a familiar sight throughout Europe.

Above, the dynamic forward sloping logotype was designed to work on ticket office fascias, aircraft and company vehicles. The union flag was sliced to sit on tail fins.

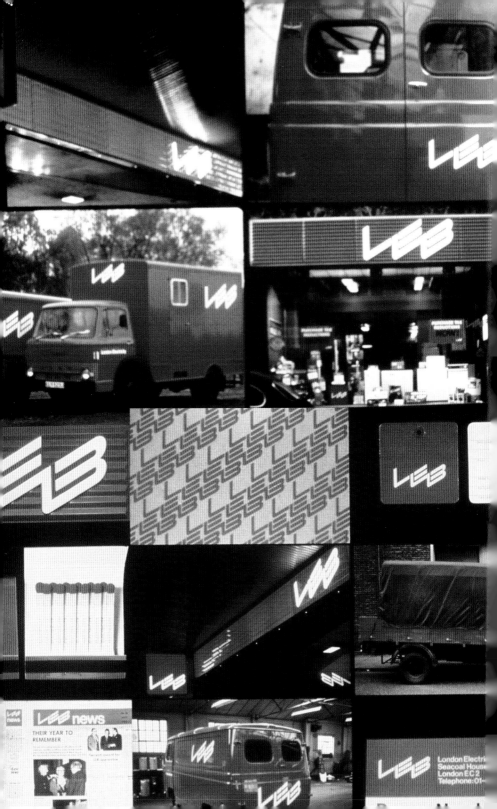

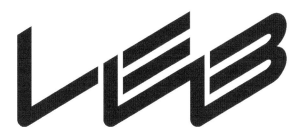

LEB, 1970. As visible as red buses and black cabs, London Electricity Board's high street shops and delivery vans made customers aware of the company's expanded retail activities and services. LEB's 'electric fire' fascias made use of new plastic moulding techniques.

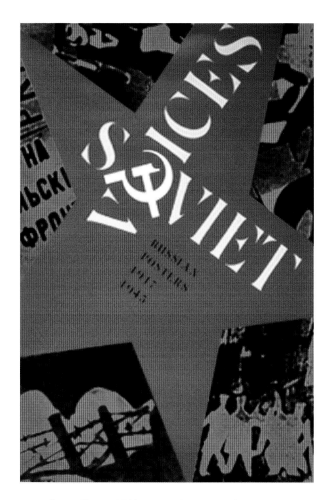

Soviet Voices, 1988. Henrion's original design announcing an exhibition of Russian posters, 1917–1945 at the Imperial War Museum. The Soviet star is superimposed over fragments of war posters.

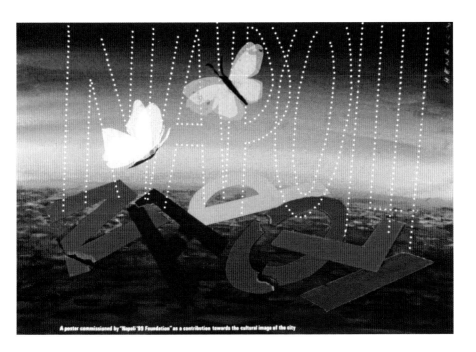

Napoli 99, 1986. The Fondazione Napoli Novantanove asked Henrion and nineteen other designers to create a series of posters to promote the urban and cultural regeneration of Naples. From the ruins, two paper butterflies fly towards the proposed rebuilt city.

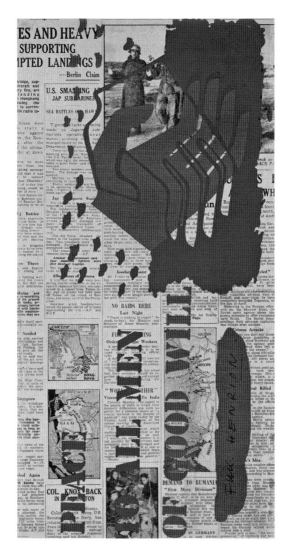

Christmas card, 1944. Henrion's personal Christmas card, stencilled onto pages torn from newspapers, anticipating post-war peace.

Chronology

1914	Born 18 April, Nuremburg, Germany
1933-34	Apprentice textile designer, Paris
1934-35	Apprentice graphic designer, Atelier Paul Colin, Paris
1936	Settled in London
1940-45	Worked for the Ministry of Information and for the US Office of War Information
1941-44	Cover designer *Harper's Bazaar* Magazine
1942-45	Ran advertising campaigns for Crawford's Advertising Co. Ltd
1946	Naturalised British
1947-52	Consultant art director for Contact Books, Adprint Ltd, Max Parrish Books, Isotype Institute Publications
1948	Established Studio H
1949-51	Designed the Agriculture and the Country Pavilions, Festival of Britain
1950-59	Tutor in graphic design, Royal College of Art
1952	MBE
1953-58	Consultant art editor *The Compleat Imbiber*
1954-58	Director of visual planning, Erwin Wasey Advertising Agency
1959-84	Consultant designer, KLM Dutch Airlines
1960-62	President of the Society of Industrial Artists & Designers
1963-66	President AGI
1964-67	Member, Council of Industrial Design
1965-67	Co-ordinating designer British Pavilion, Expo 67, Montreal
1965-68	Adviser to the Post Office on corporate identity
1968-70	President of the International Council of Graphic Design Associations (ICOGRADA), Studio H becomes Henrion Design Associates (HDA)
1970	HDA becomes Henrion Design International (HDI)
1971-73	Vice President, Royal Society of Arts
1971-73	Master of the Faculty of Royal Designers for Industry
1971-77	Chairman of the Graphic Design Board, Council for National Academic Awards
1972-79	Head of Graphic Design Department, London College of Printing
1972-89	Programme chairman ICOGRADA seminars
1974-79	Consultant designer to the Post Office
1978-87	Programme chairman AGI student seminars
1981	HDI becomes Henrion, Ludlow, Schmidt
1984	OBE
1990	Died 5 July, London

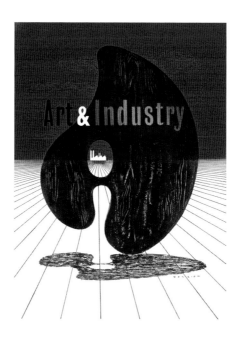